THE PHENOMENON AND CONCEPT OF ART

A linguistic gymnastic with causality

Matej Tomažin

What is the phenomenon of art?

When does it occur?

ART EXISTS IN TWO DIMENSIONS

The reciprocal-syntactic dimension of art (THE PHENOMENON OF ART):

Art can only exist if:
THERE EXISTS IS A BEING.

The being is an independent, conscious and living part of the ontologically objective dimension — existence.

Art can only exist if:
THE BEING IS PART OF THE RECIPROCAL-SYNTACTIC DIMENSION.

The reciprocal-syntactic dimension of the being consists of all physical stimuli the being is capable of sensing.

Art can only exist if: THERE EXISTS A PHENOMENON.

Phenomena are all physical forms that are sensuously available to, but not part of the being itself.

Art can only exist if: THERE EXISTS A PRIMARY SPECTATOR.

The primary spectator is the being's ability of sensory perception of phenomena.

Art can only exist if:
THERE EXISTS RECIPROCAL-SYNTACTIC SYMBOLISM.

Reciprocal-syntactic symbolism is the mode of communication in the reciprocal-semantic dimension via the assimilation of sensory impulses or capabilities of various phenomena.

What is the concept of art?

When is it created?

ART EXISTS IN TWO DIMENSIONS

The semantic dimension of art (THE CONCEPT OF ART):

Art can only function if:
THERE EXISTS A SUBJECT.

The subject is an independent, sentient, conscious living being inside the constrains of the ontologically objective dimension — existence.

Art can only exist if:
THE SUBJECT IS PART OF THE RECIPROCAL-SYNTACTIC DIMENSION.

The reciprocal-syntactic dimension of the being consists of all physical stimuli the being is capable and able of sensing, and all emotional states it is capable and able to experience.

Art can only exist if:
THERE EXISTS A PHENOMENON.

Phenomena are all physical forms that are sensuously available to, yet not part of the subject itself.

Art can only exist if:
THERE EXISTS A PRIMARY SPECTATOR.

The primary spectator is the being's ability to sense phenomena and its ability to have certain intents and wishes of acting on the basis of these sensations (the ability of perception).

Art can only exist if:
THE SUBJECT IS PART OF THE SEMANTIC DIMENSION.

The subject's semantic dimension is comprised of all concepts that it is capable of rationalising.

Art can only exist if: THERE EXISTS A SECONDARY SPECTATOR.

The secondary spectator is a projection of the subject, that — via the phenomenon — experiences itself (the act of perception).

Art can only exist if:
THERE EXIST FUNCTIONS OF PHENOMENA

Functions of phenomena are creations of the subject's projections of the secondary observer upon phenomena and create values of chaos and order.

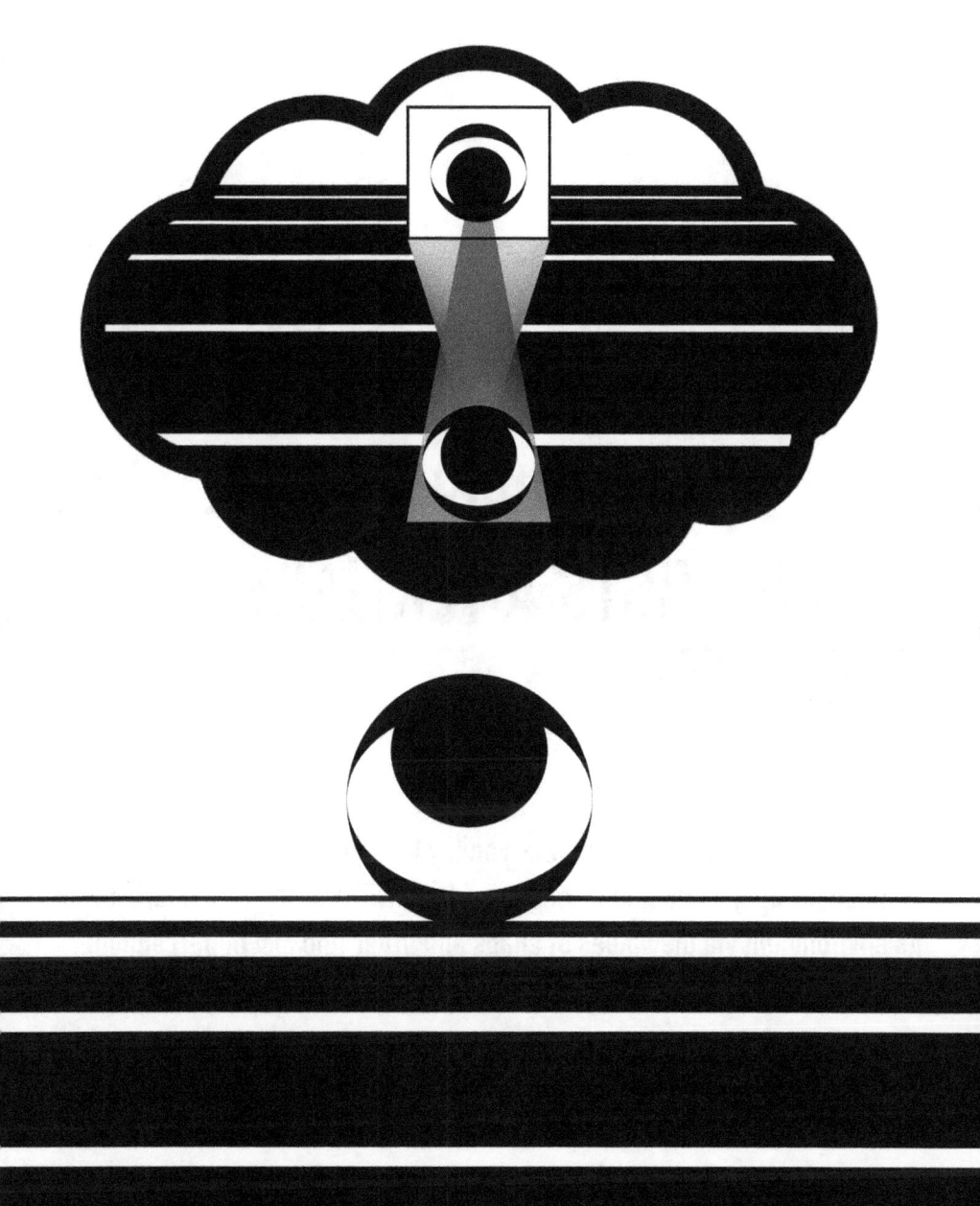

Art can only exist if:
THERE EXISTS A TERTIARY SPECTATOR.

The tertiary observer is the subject's ability to mentally simulate projections of functions upon phenomena, and provides it with the ability to interact with its environment via the values of chaos and order (the tool of perception).

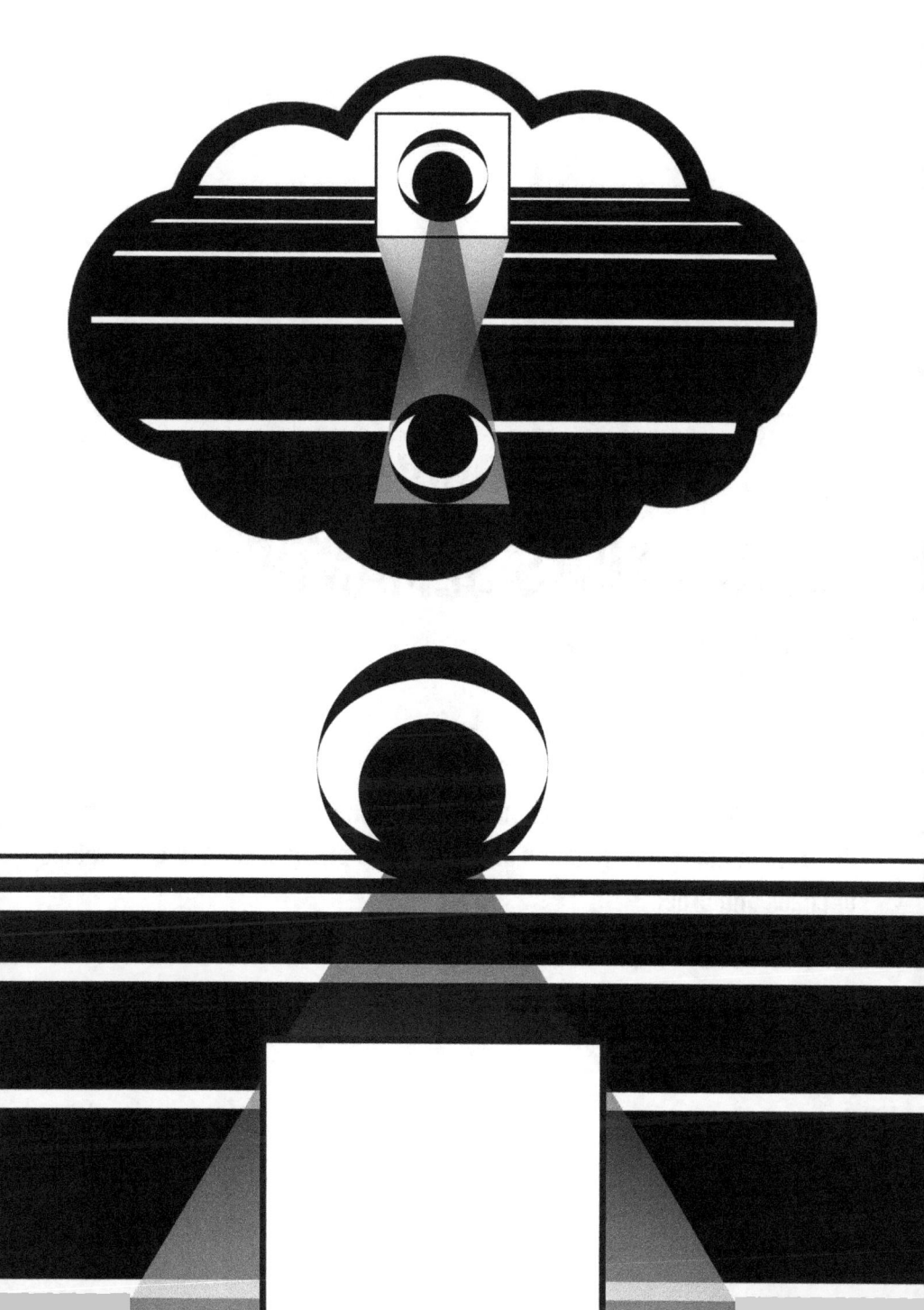

Art can only exist if:
THERE EXISTS SEMANTIC SYMBOLISM

Semantic symbolism is the communication inside the semantic dimension in the form of thought formations or functions of phenomena and their values of chaos and order.

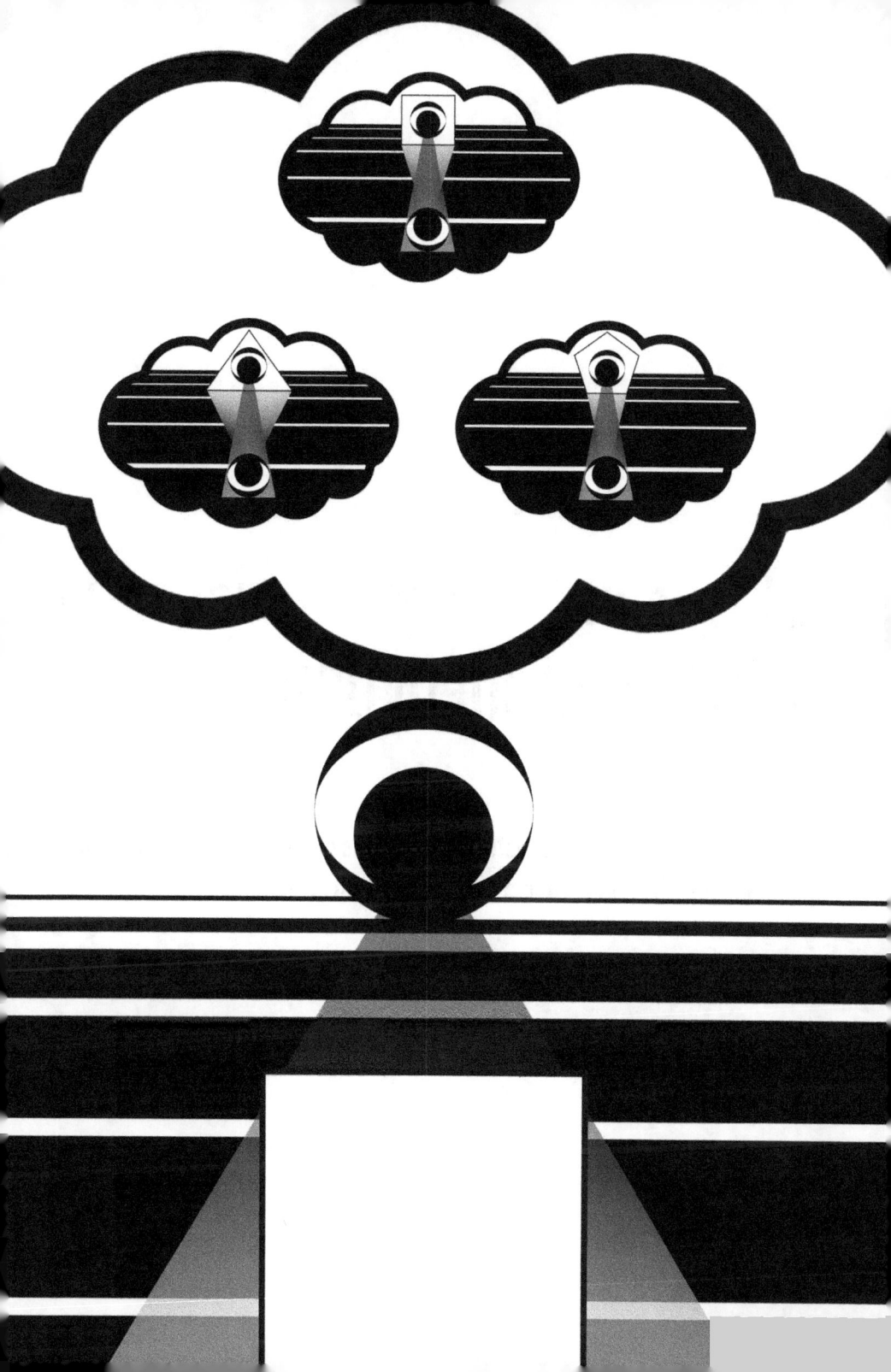

Art can only exist if:
THERE EXIST IDEOLOGIES.

Ideologies are functionally constrained systems of simulations of the tertiary spectator, via which the subject can act in its environment.

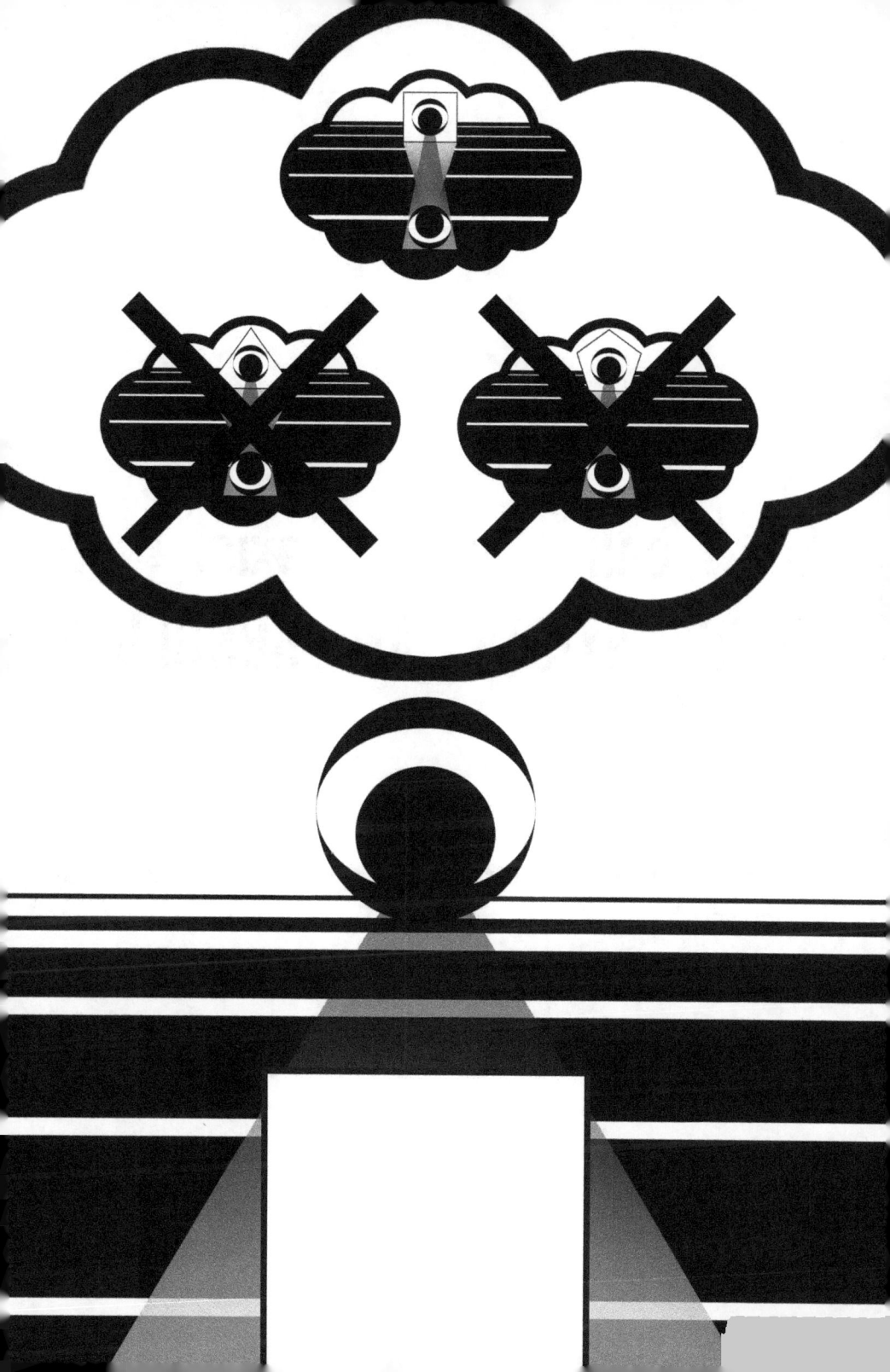

Art can only exist if:
THERE EXISTS AN ABSOLUTE IDEOLOGY.

The Absolute Ideology is an unconstrained system of simulations of the tertiary spectator.

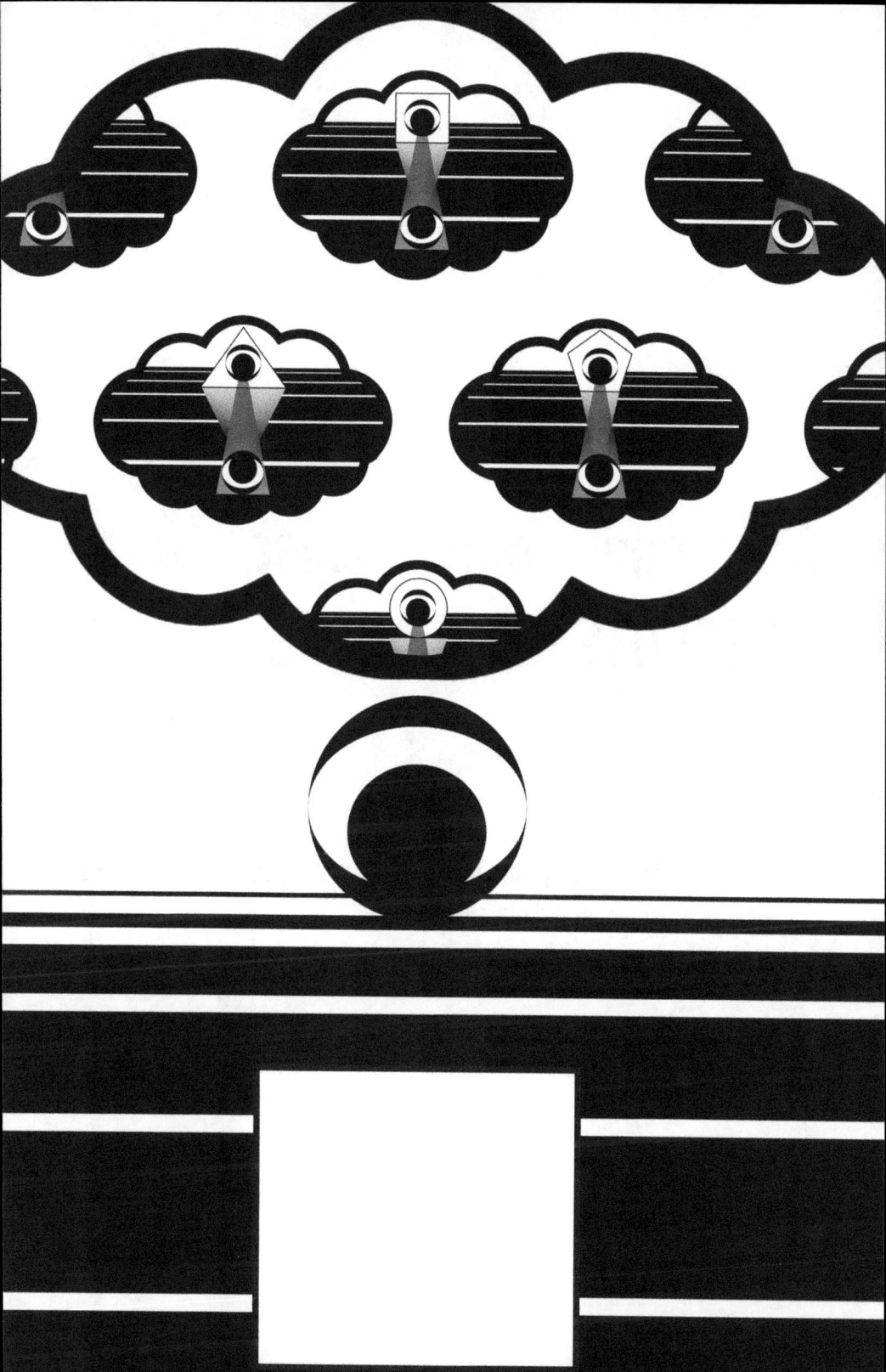

Art can only exist when: ABSOLUTE IDEOLOGY IS PROJECTED

If absolute ideology is projected by the secondary spectator, the concept of art appears in the observed phenomenon.

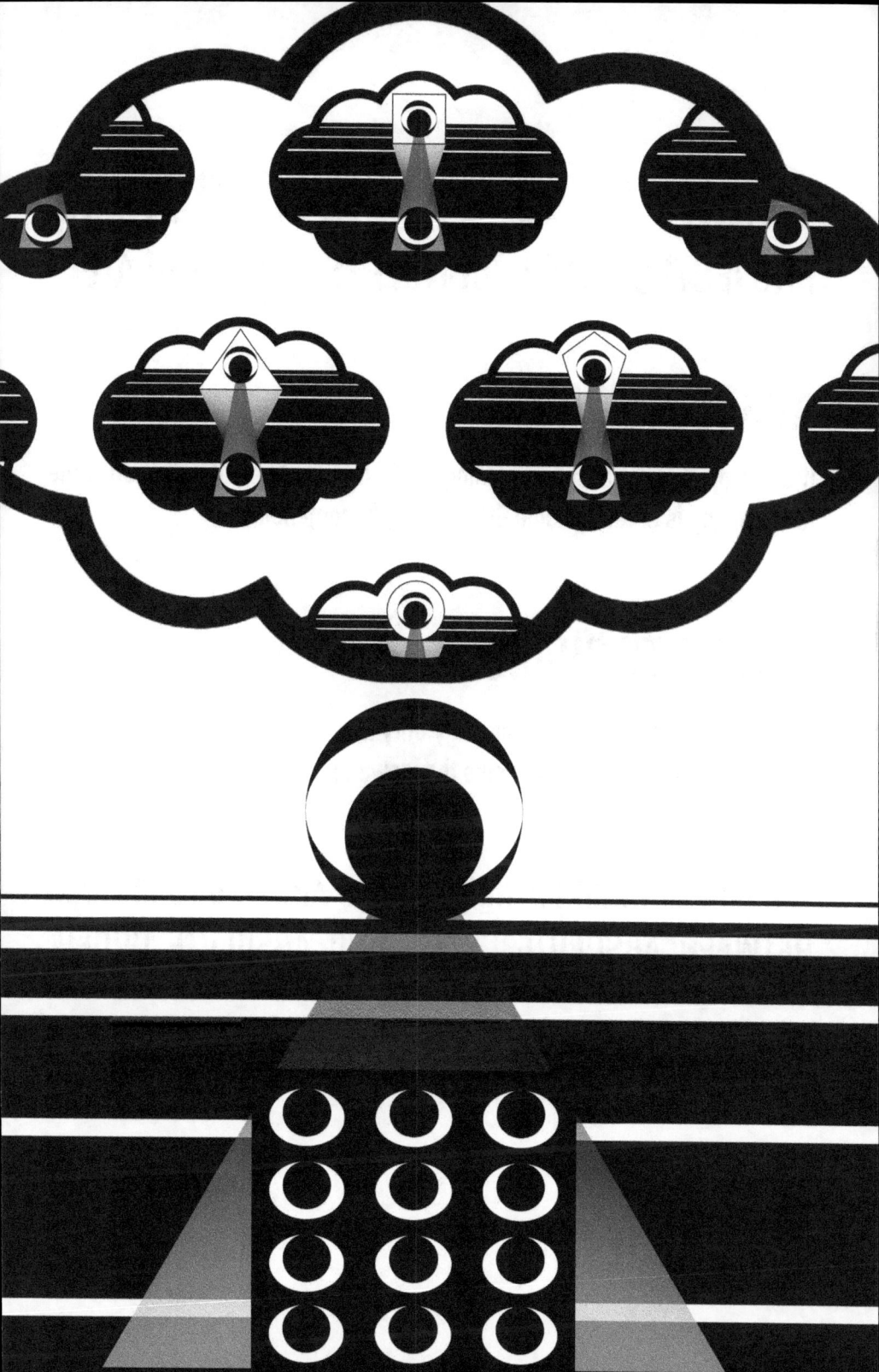

WHEN ABSOLUTE IDEOLOGY IS
PROJECTED, TWO CONCEPTS ARE CREATED:

ABSOLUTE ORDER

If the projection of absolute ideology only has qualities of order, absolute functionality is created inside the viewed phenomenon.

ABSOLUTE CHAOS

If the projection of absolute ideology only has qualities of chaos, absolute non-functionality is created inside the viewed phenomenon.

THE CONCEPT AND PHENOMENON OF ART ALWAYS OPERATE BETWEEN ABSOLUTE CHAOS AND ABSOLUTE ORDER.

www.ingramcontent.com/pod-product-compliance
Lightning Source LLC
Chambersburg PA
CBHW071444170526
45158CB00005BA/1828